out of joint

Out of Joint present

a Dish of tea with
Dr Johnson

Adapted by Russell Barr, Ian Redford and Max Stafford-Clark

from James Boswell's *The Life of Samuel Johnson*
and *The Journal of a Tour to the Hebrides*

with a foreword by Peter Martin

First performed on 22nd February 2011 at Warwick Arts Centre

D0262761

out of joint

"You expect something special from Out of Joint"
The Times

Out of Joint is a national and international touring theatre company dedicated to the development and production of new writing. Under the direction of Max Stafford-Clark the company has premiered plays from leading writers including David Hare, Caryl Churchill, David Edgar, Alistair Beaton, Sebastian Barry and Timberlake Wertenbaker, as well as introducing first-time writers such as Simon Bennett, Stella Feehily and Mark Ravenhill.

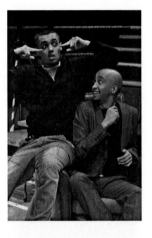

"Max Stafford-Clark's excellent Out of Joint company"
The Independent

Touring all over the UK, Out of Joint frequently performs at and co-produces with key venues such as the Royal Court and the National Theatre and recently with Sydney Theatre Company. The company has performed in six continents. Back home, Out of Joint also pursues an extensive education programme.

"Out of Joint is out of this world"
Boston Globe

Also in 2011: we take our acclaimed production of Richard Bean's *The Big Fellah* on tour in Ireland and England; Max Stafford-Clark revisits Caryl Churchill's *Top Girls* in a new production; *Bang Bang Bang* by Stella Feehily; and supporting a new play to be directed by Des Kennedy, the recipient of our new Associate Director bursary.

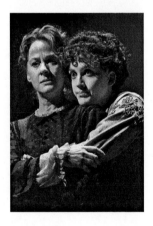

Above: *Mixed Up North* (2009) by Robin Soans, photo by Ian Tilton
Below: *Andersen's English* (2010) by Sebastian Barry, photo by Robert Workman

Supported by
**ARTS COUNCIL
ENGLAND**

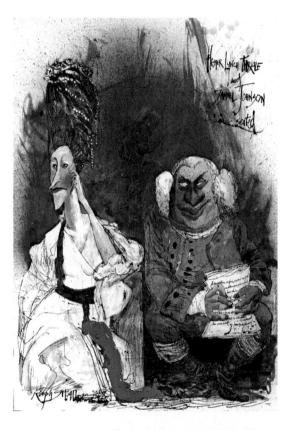

Samuel Johnson and Hester Thrale

THE COMPANY

Cast (in order of appearance)

Dr. Samuel Johnson	Ian Redford

Mr. James Boswell	
Mrs. Anna Williams	
Mr. Oliver Goldsmith	
Sir Joshua Reynolds	
Lady Flora MacDonald	Russell Barr
King George III	
Mr. Edward Dilly	
Mr. John Wilkes	
Mrs Hester Thrale	

Hodge, the cat	Katie

Director	Max Stafford-Clark
Designer	Tim Shortall
Lighting Designer	Christopher Nairne
Costume Designer	Karen Large
Wig Supervisor	Sally Tynan
Associate Director	Des Kennedy
Dialect Coach	Charmian Hoare
Stage Manager	Kitty Stafford-Clark

Grateful thanks to Richard Davies at the Dr Johnson Society, and to Stephanie and Morwenna at Dr Johnson's House for their kindness, time and expertise.

RUSSELL BARR
Performer and Adapter

Out of Joint produced Russell's first play *Sisters Such Devoted Sisters* (which he also performed) which toured nationally and internationally, winning the Scotsman/Carol Tambor Award for the Best Production at the Edinburgh Festival in 2004. It was given a new production in New York, directed by *The Sopranos* star Michael Imperioli. Other acting includes Out of Joint's world premiere productions of Mark Ravenhill's plays *Shopping and Fucking* and *Some Explicit Polaroids*, and films including *The Slab Boys*, *Regeneration*, *About a Boy*, *The Land Girls*, and *The Gathering Storm*. Russell's other writing includes *The Super Slash Naughty XXXmas Story* (Wilton's Music Hall); *Diva Danny* (a musical about the life of Danny Barrett and Bloolips) at Soho Theatre; and most recently two one-act plays, *Lobster* and *Vantastic* (Oval House). He directed *Heelz on Wheelz* at Manchester Royal Exchange. Russell is a recipient of several awards from The Peggy Ramsay Foundation, and is supported by the Arts Council. Future projects include a commission for the Olympics, *Der Hassliche Geist* (The Ugly Spirit) and a project, *Colony*, set in a prison. Russell has recently been shortlisted for the Samuel Beckett Prize.

Russell would like to thank the following for their continued support: Alan Rickman, St John Donald, Rachel Hopkins, Ruth Young, Jess Alford, Sally and Graham Crowley, Peter Martin, Natasha Davis, Lois Keidon, Ian Redford, Max Stafford-Clark and everyone at Out of Joint, April De Angelis, Joanna Scanlan, Marjory and Ronnie Barr, Auntie Sheila Livingstone, Andrew Walby and everyone at Oberon Books, Stephanie and Morwenna at the Johnson House.

GRAHAM COWLEY
Producer

Out of Joint's Producer since 1998. His long collaboration with Max Stafford-Clark began as Joint Stock Theatre Group's first General Manager for seven years in the 1970s. He was General Manager of the Royal Court for eight years, and on their behalf transferred a string of hit plays to the West End. His career has spanned the full range of theatre production, from small fringe companies to major West End shows and large scale commercial tours. Outside Out of Joint, he has translated Véronique Olmi's *End of Story* (Chelsea Theatre) and has produced the 'Forgotten Voices from the Great War' series of plays including *What the Women Did* (Southwark Playhouse, 2004), *Red Night* by James Lansdale Hodson (Finborough, 2005) and *My Real War 1914-?,* based on the letters of a young WW1 soldier, which toured twice in 2007 and played at Trafalgar Studios in October 2009.

KATIE
Performer

Katie, the Jack Russell Terrier, was rescued by Russell Barr from a high rise block in Kilburn. She was very mistreated there, but has been living with Russell and her adoptive brother Gordon, who came from Battersea Dogs and Cats Home, for seven years and has made a very good recovery. Katie does not know her age, but she has gone a little grey and lost most of her teeth so we imagine her to be around thirteen years. She is now a rather bossy, happy dog, who enjoys mostly Pedigree Chum, sleeping in a bed, and panting. She doesn't like fireworks, or diesel fuelled vehicles. Katie appeared (on film) in Russell's play *The Super Slash Naughty XXXmas Story* (Wilton's Music Hall) playing the Virgin Mary. She has had no professional training but is thrilled to be playing Hodge, Johnson's beloved cat. Through time, and injury, she has come to like cats, especially kittens. She is also, like Hodge, fond of oysters. Katie is currently seeking representation.

DES KENNEDY
Associate Director

Des Kennedy is originally from Belfast. He was on the National Theatre Studio Directors' Course in 2010 and has worked as an Assistant Director under Dominic Cooke at the Royal Court and Mike Bradwell at the Bush. Previous directing credits include *The Prophet of Monto* (Flea Theater, New York); *JonnyMeister + the Stitch* (Mead Theatre, Washington D.C.); *The Great Ramshackle Heart* (Old Vic New Voices/Public Theater, New York); *Dying City* (Project Arts Centre, Dublin); *Seven Jewish Children* (Queen's Studio, Belfast); *Salaam Mr Bush!* (rehearsed reading, Royal Court Young Writers Festival); *The Last Days of Judas Iscariot* (Brian Friel Theatre, Belfast); *Scenes from the Big Picture* (Callan Theatre, Washington D.C. - Helen Hayes nominated production and named one of the best 10 productions of the decade, Washington Post); *The Laramie Project* (National Student Drama Festival 2004, Bush Theatre Directing Award). Des is currently Out of Joint's Associate Director.

KAREN LARGE
Costume Designer

Karen worked with Out of Joint on *Andersen's English*. She has worked in theatre since 1977, including on the RSC Mermaid season and West End productions such as *On Your Toes* and *Return to the Forbidden Planet*. For the past couple of years she has been working with Hackney Music Development Trust, first on the vast, RPS Award-winning project *Confucius Says*, as both Costume Supervisor and Art Coordinator; and recently for *Shadow Ball*. She is currently costume-supervising English Touring Opera's Spring season and will return to Out of Joint for the revival of *The Big Fellah*.

CHRISTOPHER NAIRNE
Lighting Designer

Christopher is a freelance lighting designer, production electrician and flyman based in London. Recent lighting design credits include: *La Bohème* (Cock Tavern and Soho Theatre transfer); *Palace of the End* and *The House of Mirrors and Hearts* (Arcola Theatre); *The Captive* and *Generous* (Finborough Theatre); *She Stoops to Conquer* and *The Boy I Love Is Up in the Gallery* (Hoxton Hall); *Fair Trade* (Latitude, Rich Mix & Edinburgh Fringe); *The Jewish Wife, Miss Julie* and *The Fastest Clock in the Universe* (Battersea Arts Centre); *Anyone Can Whistle* (Jermyn Street Theatre); *Henry V* (Southwark Playhouse); and *Hedda* (Riverside Studios). He has also designed all the lighting for cabaret duo Frisky and Mannish, recently including *Frisky and Mannish's Christmas Mess... age* (Lyric Theatre), *Frisky and Mannish: The College Years* (Riverside Studios, Edinburgh Fringe & UK tour) and *Frisky and Mannish's School of Pop* (Edinburgh Fringe & UK/ international tours). Further details, and a full list of credits, are available on his website: www.christophernairne.co.uk

IAN REDFORD
Performer and Adapter

Ian's appearances with Out of Joint include *Shopping and Fucking, Our Country's Good, Some Explicit Polaroids, Rita Sue and Bob Too, A State Affair, A Laughing Matter* (in which he first played Dr Johnson), *She Stoops To Conquer* and *The Permanent Way*. Other theatre includes, for the National Theatre: *Mother Clap's Molly House* and *Love The Sinner*; for Manchester Royal Exchange: *Antigone* (nominated for Best Actor at the Manchester Evening News Awards) and *Dr Faustus*; *Romeo and Juliet* (Shakespeare's Globe); *All My Sons* (The Curve, Leicester); *Six Degrees of Separation* (Old Vic, London). TV work includes two years as Keith Appleyard in *Coronation Street*; *The Devil's Whore, Henry VIII: The Mind of a Tyrant, EastEnders, Casualty, The Bill, Derailed, The History File, Table Twelve*. Films include *The Legend of the Boogeyman, Remains of The Day, Stone, Scissors, Paper, The Prince and the Pauper, Getting It Right, Spaghetti House Siege, Three Men and a Little Lady, Annie*. He was the founder and Artistic Director of Xenia Theatre Company.

Ian would like to thank Catherine Dill and Nicholas Cambridge for their advice and encouragement. Ian would also like to thank Kay and Archie Redford for putting up with his obsession.

TIM SHORTALL
Designer

Tim's previous designs for Out of Joint are *The Overwhelming* (also at the National Theatre and Laura Pels Theatre New York); *King of Hearts* (also at Hampstead Theatre) and *The Big Fellah* (Lyric Hammersmith). Current work includes *La Cage Aux Folles* on Broadway (2010 Tony Nomination Best Design of a Musical) and previously at the Playhouse Theatre, the Menier Chocolate Factory production of *Sweet Charity* (Theatre Royal Haymarket), and

recently Trevor Griffiths' epic *A New World – The Life of Thomas Paine* at Shakespeare's Globe. Tim has an extensive list of credits in London and the West End which include *The Philanthropist*, directed by David Grindley with Simon Russell Beale at the Donmar Warehouse and Matthew Broderick in New York; *Awake and Sing* with Stockard Channing directed by Michael Attenborough at the Almeida; *See How They Run* directed by Douglas Hodge (Duchess Theatre); and for Terry Johnson: *Rookery Nook* (Menier Chocolate Factory); *Whipping It Up* (Ambassadors); and *Elton John's Glasses* (Queens Theatre). Other London work includes *Telstar*, *Body and Soul*, *Murder By Misadventure*, *The Cooks Tour*, the costumes for *The Big Knife*, *Excuses* for David Grindley, *Haunted*, *The Amen Corner*, *900 Oneonta* (Old Vic), *What You Get And What You Expect*, *Eugene Onegin* (Lyric Hammersmith*)* and *Disappeared* (Royal Court). Tim has designed for most of the major regional theatres in the UK and highlights include, for Rupert Goold: *Privates On Parade*, *The Colonel Bird* and *Broken Glass*; *Single Spies* and *Having A Ball* for David Grindley; and *Roots* (Barclays TMA Award nomination for Best Design). Designs for dance include *Private City/ Track and Field* (Sadler's Wells Royal Ballet); *Sonata In Time* (Scottish Ballet); *Rhyme Nor Reason* and *Party Game* (Norwegian National Ballet); and *The Nightingale* (Dutch National Ballet). Television work includes *20th Century Blue; a tribute to Noel Coward* with Robbie Williams and Elton John (BBC); and *The Nightingale* (NOS Dutch TV) which was the Netherlands' entry in the Prix Italia and won the RAI Prize for Best Design.

MAX STAFFORD-CLARK
Director and Adapter

Educated at Trinity College, Dublin, Max Stafford-Clark co-founded Joint Stock Theatre Group in 1974 following his Artistic Directorship of The Traverse Theatre, Edinburgh. From 1979 to 1993 he was Artistic Director of the Royal Court Theatre. In 1993 he founded the touring company, Out of Joint. His work as a Director has overwhelmingly been with new writing, and he has commissioned and directed first productions by many leading writers, including Sue Townsend, Stephen Jeffreys, Timberlake Wertenbaker, Sebastian Barry, April de Angelis, Mark Ravenhill, Andrea Dunbar, Robin Soans, Alistair Beaton, Stella Feehily, David Hare and Caryl Churchill. In addition he has directed classic texts including *The Seagull*, *The Recruiting Officer* and *King Lear* for the Royal Court; *A Jovial Crew*, *The Wives' Excuse* and *The Country Wife* for The Royal Shakespeare Company; and *The Man of Mode*, *She Stoops to Conquer*, *Three Sisters* and *Macbeth* for Out of Joint. He directed David Hare's *The Breath of Life* for Sydney Theatre Company in 2003. Academic credits include an honorary doctorate from Oxford Brookes University and Visiting Professorships at the Universities of Hertfordshire, Warwick and York. His books are *Letters to George* and *Taking Stock* and the new 'Page to Stage' guide to *Our Country's Good*.

FOREWORD

by Peter Martin

The tercentenary of Samuel Johnson's birth (2009), with its multitude of celebrative global events and conferences and extensive media coverage, reminded the English-speaking world of the greatness and infinite variety of one of England's most remarkable authors. A literary colossus and polymath, the foremost literary figure of his age, for more than two centuries after his death Johnson has remained a British cultural icon and is after Shakespeare the second most quoted author in British history. He seems larger than life, a prodigy of extraordinary intellect and the author of magnificent prose that grows richer with repeated reading, but he is also very accessible to us as a very human and emotionally complex man from whose life and writing we can learn much about the art of living. Bewigged, muscular, and for his day unusually tall, dressed in soiled, rumpled clothes, beset by involuntary tics, opinionated, powered in his conversation by a prodigious memory and intellect, Johnson was in his day a social and literary icon as no other age has produced.

Now in this play *A Dish of Tea with Dr. Johnson* from the Out of Joint Theatre Company, adapted from James Boswell's *Life of Samuel Johnson* and *Journal of A Tour to the Hebrides*, that memorable image of Johnson is so vividly recaptured that one feels one is transported to Johnson's London house, sipping tea with the great man, drinking in also the inimitable dynamic of late eighteenth-century London. We are reintroduced with wit, deftness, and a rhythmic seamlessness to Johnson's compelling, authoritative personality and his seemingly endless capacity for talk and insights into just about any topic that happens to come up in conversation, among them his cat Hodge, critics, grief, death (which he mightily feared), melancholy (from which he suffered acutely), his eccentric household, poverty, drink, morality, predestination and free will, and – of course – his monumental *Dictionary of the English Language*. Boswell also gets into the act prominently and typically with his persistent and at times (to Johnson) annoying questions. Other characters too move in and out of the developing portrait of Johnson: the blind housekeeper Mrs Williams, Sir Joshua Reynolds, the political firebrand John Wilkes, Oliver Goldsmith, and Johnson's intimate friend Hester Thrale.

I went along to an early rehearsal/performance of this play at Out of Joint's on-site rehearsal hall at Finsbury Park and was immediately struck by how well put together this play is, especially by the way Johnson's writings are blended artfully with biographical material drawn from Boswell's biographies. This is important and as a biographer of Johnson I find it refreshing because the authors and director do not make the mistake often made in stage drama about Johnson of traveling merely in the clichés about him, his boisterous rudeness and argumentativeness, physical grotesqueness, proverbial wit, and so on.

Instead, we get a full and rounded interplay between Johnson and Boswell, by the end of which the depth of character of both men, as well as their cherished intimacy, has been poignantly unfolded. In particular, when they speak of melancholia, or depressive gloominess, which afflicted them both and to some extent drew them together, we see the clouds gathering on Johnson's brow and feel the theme resonating for us today. It is the same with death, politics, women in society, friendship – the list goes on. Mrs Thrale's entrance also adds a deeper personal intimacy and privacy that not only puzzled London society at the time but also today continues to be a controversial subject: was Johnson romantically in love with her, did they have intimate relations, did he really fancy marrying her after her husband died? There is a good deal of humour as well in all of this, which authentically enhances the dialogue and spices the play with the exuberance that characterizes Johnson's era.

What with Johnson's tercentenary, Boswell's biographies, Johnson's own writings, the famous *Dictionary,* and the continued citing of Johnson's words in the press, in films and advertisements, by politicians – by all of us in fact – it is a wonder that he is not at least as well known in Britain as, for example, Wordsworth. I did a little survey in several high streets of England, asking people if they could say who he was. Only about twenty percent could. Given Johnson's iconic status – a fifty pence coin in 2005 was minted with his name on it – that is surprising enough, but among those few could say anything more than that he was the author of a dictionary. Out of Joint's *A Dish of Tea with Dr. Johnson* brings us close to Johnson and may well induce many in its audiences to read him and thereby draw even closer.

Peter Martin

"A Sure Retreat" – Johnson's kindness at home

by Stephanie Chapman

Johnson said 'a man, Sir, should keep his friendships in constant repair' and he could count among his acquaintance eminent politicians, lawyers, publishers, writers and painters. His impressive circle of friends included the actor and theatre manager, David Garrick; first President of the Royal Academy, Sir Joshua Reynolds; and society hostess and literary patron, Elizabeth Montagu.

However, to fully understand Johnson's character and motivations, as well as to gain an insight into his day-to-day life, we need to look closer to home. The members of Johnson's household in London have unfamiliar names and even less familiar stories, but their relationship with Johnson casts a unique light on his character.

Johnson suffered from depression, or 'melancholy' as he would have called it. An effect of this was a fear of returning home to an empty house where his thoughts could run riot with little distraction. After the death of his wife, Tetty, in 1752, Johnson gradually filled his home with an assortment of impoverished characters, to many of whom he offered lifelong support.

One of these was Robert Levett, who was the subject of perhaps the most touching epitaph that Johnson ever composed. Levett was a dedicated doctor to the poor, walking for miles on his daily rounds. He had travelled in his youth and had attended medical lectures in Paris, picking up a reasonable knowledge of the profession and an impressive medical library. Levett was a rather short, smelly – one might even say grotesque – man, with a face scarred by smallpox. He spent his time attending to London's poor, who could not afford a normal physician's fees. Sometimes Levett's patients would have nothing more to offer than a glass of intoxicating (but extremely cheap) gin causing Levett frequently to return from his rounds a little worse for wear. Johnson's friends were often surprised by his choice of housemate but, as Oliver Goldsmith reported, Levett was 'poor and honest' and that was recommendation enough for Johnson.

> Well try'd through many a varying year,
> See Levett to the grave descend;
> Officious, innocent, sincere,
> Of every friendless name, the friend.

(from Johnson's *On the Death of Mr Robert Levett, a Practiser in Physic*)

Another long term member of Johnson's household was his manservant Francis Barber. Barber was a former slave from Jamaica who had grown up on the sugar plantations. His owners, the Bathurst family, brought him back to England with them and, after Johnson's wife's death, presented Barber to the grieving Johnson. Johnson never treated Barber as a slave. He paid for him

to be extensively educated, went to great lengths to get him released from the navy to return to his service (perhaps not altogether to Barber's delight) and, most unusually for the time, left most of his inheritance to Barber. Barber entered Johnson's household when he was about 10 years old and was still in his employment when Johnson died. Johnson, a life-long opponent of the slave trade, practiced what he preached in his treatment of Barber.

However, life in the Johnson household was not altogether easy for Barber, and he would frequently bear the brunt of a fellow lodger's temper: Anna Williams gained a rather bad, but deserved reputation in her later years for being peevish and argumentative. But at the start of their friendship she provided a pleasant companion for Johnson's wife Tetty, and, after Tetty's death acted as a housekeeper and companion for Johnson. Williams had little means of supporting herself and an operation to remove the cataracts that affected both her eyes had failed, leaving her blind when she was only in her thirties. Johnson found in Williams a pious lady, who was well informed with interesting conversation. She was also rather adept at manning the kettle late into the night ensuring Johnson could partake of his favourite beverage, tea, after coming home from the pub. Johnson not only supported Williams himself – she was to remain his dependent for the rest of her life – but went to great lengths to improve her income by using his contacts to stage a benefit play on her behalf and help publish her work. Later in life Williams' famed temper seemed to override her other qualities and she was constantly bickering with the other inmates in the Johnson household.

As Johnson got older, his household expanded. Later lodgers included Pol Carmichael, reputed to be a former prostitute whom Johnson had rescued from the streets; and Mrs Desmoulins, an old friend of Tetty's and the daughter of his godfather.

Johnson's household was chaotic and often fractious. In addition to his long term lodgers he would often let others stay: often literary men who were down on their luck. Johnson's great friend Mrs Thrale said Johnson 'nursed whole nests of people in his house, [a place] where the lame, the blind and the sorrowful found a sure retreat from all the evils whence his little income could afford'. Lifelong Johnson fan, Samuel Beckett, was to find inspiration in these eccentric and impoverished members of Johnson's household for his unfinished play, *Human Wishes*. Johnson clearly had respect and affection for his lodgers, and they in turn provide proof of Johnson' humanity, generosity and sympathy for the plight of the poor.

Stephanie Chapman is the Donald Hyde Curator of Dr Johnson's House
Dr Johnson's House, 17 Gough Square, London EC4A 3DE
Open to the public six days a week
www.drjohnsonshouse.org / 020 7353 3745

A DISH OF TEA WITH DR JOHNSON TOUR 2011

TUE 22 – WED 23 FEB
WARWICK ARTS CENTRE

FRI 25 FEB
BALCONY THEATRE,
BURNHAM OVERY STAITHE

MON 28 FEB
STEPHEN JOSEPH THEATRE,
SCARBOROUGH

TUE 1 MAR
DARLINGTON ARTS CENTRE

WED 2 – SAT 3 MAR
THE THEATRE, UNIVERSITY OF YORK
(Dept of Theatre, Film & TV, Heslington East Campus)

FRI 4 – SAT 5 MAR
CUSTOMS HOUSE THEATRE,
SOUTH SHIELDS

MON 7 MAR
IPSWICH HIGH SCHOOL FOR GIRLS

TUE 8, THU 10 & FRI 11 MAR
DR JOHNSON'S HOUSE, LONDON

SAT 12 MAR
NORDEN FARM ARTS CENTRE,
MAIDENHEAD

TUE 15 – THU 17 MAR
SALISBURY PLAYHOUSE

SAT 19 MAR
EASTWELL MANOR, ASHFORD

23 MAR
THE CASTLE, WELLINGBOROUGH

THU 24 MAR
LICHFIELD GARRICK

SAT 26 MAR
THEATRE ROYAL,
BATH (USTINOV STUDIO)

MON 28 MAR
LAWRENCE BATLEY THEATRE,
HUDDERSFIELD

TUE 29 MAR
TOWN HALL CRYPT, MIDDLESBROUGH

WED 30 MAR
THE CARRIAGEWORKS, LEEDS

THU 31 MAR
GEORGIAN THEATRE ROYAL,
RICHMOND (N. YORKS)

FRI 1 - SAT 2 APR
LIVE THEATRE NEWCASTLE

MON 4 APR
NORWICH PLAYHOUSE

TUE 5 APR
STANTONBURY CAMPUS THEATRE,
MILTON KEYNES

WED 6 APR
HAWTHORNE THEATRE,
CAMPUS WEST, WELWYN GARDEN CITY

THU 7 APR
PEGASUS, OXFORD

FRI 8 AND SAT 9 APR
THE BREWHOUSE, TAUNTON

www.outofjoint.co.uk

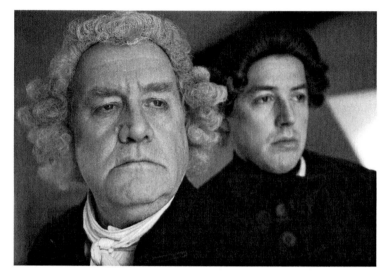

Ian Redford and Russell Barr

Image © Robert Workman

This book is dedicated to April De Angelis:
without her encouragement this project would never have surfaced.
Also to Pete Postlethwaite, a great friend and prodder...

Adapted by Russell Barr,
Ian Redford and Max Stafford-Clark

A DISH OF TEA
WITH DR JOHNSON

from James Boswell's *The Life of Samuel Johnson*
and *The Journal of a Tour to the Hebrides*

OBERON BOOKS
LONDON

First published in 2011 by Oberon Books Ltd
521 Caledonian Road, London N7 9RH
Tel: 020 7607 3637 / Fax: 020 7607 3629
e-mail: info@oberonbooks.com
www.oberonbooks.com

A catalogue record for this book is available from the British
Library.

ISBN: 978-1-84943-106-4

Cover image and title treatment by Jon Bradfield, Out of Joint.

Printed in Great Britain by CPI Antony Rowe, Chippenham.

Characters

DR SAMUEL JOHNSON

MR JAMES BOSWELL

MRS ANNA WILLIAMS

MR OLIVER GOLDSMITH

SIR JOSHUA REYNOLDS

LADY FLORA MACDONALD

KING GEORGE III

MR EDWARD DILLY

MR JOHN WILKES

MRS HESTER THRALE

HODGE, THE CAT

JOHNSON: Ah, so you've come. You are expected. I won't enquire why you've no better business to be about, that Sirs, would be an impertinence. Let us conclude that having a spare hour or so and being in the vicinity you have come to pay your respects to a poor man, and his company.

I am known as Dictionary Johnson, failed dramatist, successful essayist, biographer critic, Latinist, epigramist, writer of prologues, prefaces, epic poems and parliamentary reports, a master conversationalist, clubman, shameless tea drinker, and enemy of 'cant' in all its forms whether in life or in books.

Ah… Yes… What…? Welcome, welcome. I am about to ask dear Mrs Williams to make some tea. Would you like some? Mrs Williams is blind, and a little peevish, but makes excellent tea, and I enjoy her company. Tea I find very beneficial, as indeed the company it brings. My house is full of vagabonds that no sane person would have near them. The fragrant leaf, I drink it at all times and at all hours. I have been known to drink up to fourteen cups at one sitting. I hope that you might all stay with me for a while, I hate sleep, and lie down only to endure oppressive misery, and soon rise again to pass the night in anxiety and pain. I depend on company.

I am Dictionary Johnson! Robert Dodsley a bookseller first put it to me to write a dictionary. I had long thought of it myself but when Dodsley first suggested it I thought I would not undertake the task, but Dodsley persisted and formed a consortium of publishers, Dodsley, Andrew Millar, Thomas Longman and others. A contract was signed and over the next nine years they handed over 1575 pounds in larger and smaller sums. No man but a blockhead ever wrote except for money. I have never been very good with money. I am awkward in counting it. But the reason is plain. I had very little money to count. But I believe that getting money is not all a man's business.

Cultivating kindness is a valuable part of the business of life. My philosophy is correct. But my pocket is still empty.

JOHNSON reads from his dictionary.

LEXICOGRAPHER; A writer of dictionaries; a harmless drudge, that busies himself in tracing the original, and detailing the significant words.

It is the fate of those who toil at the lower employments of life, to be rather driven by the fear of evil, than attracted by the prospect of good, to be exposed to censure, without hope of praise, to be disgraced by miscarriage, or punished for neglect. Among these unhappy mortals is the writer of dictionaries, whom mankind have considered not as the pupil, but the slave of science, the pioneer of literature, doomed only to remove rubbish and clear obstructions from the paths of learning and genius. Every author may aspire to praise, the lexicographer can only hope to escape reproach, and even this negative recompense has been yet to be granted to very few. Dictionaries are like watches, the worst is better than none and the best cannot be expected to go quite true.

Enter BOSWELL.

I was telling these gentlemen that Dodsley first mentioned to me the scheme of an English Dictionary but I had long thought of it. And now I have done it. It took me eight years.

BOSWELL: And it took the French forty and you have done it well. Indeed you have Sir. You need fear no critic.

JOHNSON: Fear a critic Sir? Why a critic is a species of dung beetle. A fellow who makes himself fat upon other men's droppings.

BOSWELL: Yet you must allow that they can sting a little Sir.

JOHNSON: Why Sir a fly may sting a horse, but at the day's end the fly is but an insect, while the horse remains /a noble animal still.

BOSWELL: I meant only to say Sir, that even your most rigorous Patron / must be delighted with the work.

JOHNSON: Talk neither to me of Patrons Sir. I have laboured many years without the smile of favour from my patrons. I take a patron to be one who looks with unconcern for a man struggling for life in the water, and when he reached ground, encumber him about with help. Mrs Williams! These gentlemen wait upon tea.

BOSWELL exits.

The fish I carry is for Hodge, my cat, for though a man may starve Sirs, he shall not suffer his domestic pets to languish in the same fashion. Because they would run off. Hodge is getting old now, and is sick and can eat nothing but fresh fish and oysters. I do not suffer the servants to bring his supper. I have no desire to hurt anyone's feelings. They should not see themselves employed for the convenience of a quadruped. It is by the study of little things that we understand ourselves. I am Dictionary Johnson. You are welcome.

Hodge is here about, he may introduce himself, or not as the fancy takes him. He is the most discerning animal. Where is that cat. Hodge? Hodge?

He reads from his dictionary.

CAT; a domestic animal that catches mice, commonly reckoned by naturalists the lowest order of the leonine species.

It is by the study of little things that we attain the great art of having as little misery and as much happiness as possible.

HODGE enters, carried by BOSWELL.

Ah, Hodge. There you are.

JOHNSON picks up HODGE. He looks the cat in the eye.

You are the greatest friend. You cause me no trouble.

JOHNSON gives a plate of food to HODGE.

Your supper Hodge. But what you will Sir. Hear this. All intellectual improvement arises from leisure. I have the happiest conversation with you dear Hodge, as there is no competition, no vanity, but a calm, quiet interchange of sentiments. You are the greatest friend. You cause me no trouble.

JOHNSON embraces BOSWELL like he is a sack of potatoes.

And here is another dear friend. I hope we shall pass many years of regard together Bozzy, Bizzy, Bozzy. I love the acquaintance of you young people Bozzy, because in the first place, I don't like to think of myself turning old. In the next place, young acquaintances must last longest and young men have more virtue than old men. They have more generous sentiments in every respect. I think dear Bozzy that two of the best things that ever happened to me were meeting you and the granting of my pension. If a man does not make new acquaintances as he advances through life, he will soon find himself left alone. A man, Sir, should keep his friendship in a constant repair. Friendship, like love, is destroyed by long absence, though it may be increased by short intermissions.

BOSWELL: Thank you Sir. That moves me. I am sorry Sir, I did not realise that you have company, I shall call back the Morra'.

BOSWELL goes to exit.

JOHNSON: Stay Bozzy! You are welcome. They have come to pay respects to a poor man, being me, and his company. Would you like tea?

BOSWELL: Why yes Sir. But you are most certainly in company.

JOHNSON: As to the quality of the company, Bozzy, that I am unsure of.

BOSWELL: I am afraid that I intrude upon you. It is benevolent to allow me to sit and hear you.

JOHNSON: Sir I am obliged to any man who visits me. I believe that a man is only happy in his school days, or when he is drunk, or when he is lying in his bed in the morning. No man is happy but as he is compared with being miserable. There are many innumerable questions to which the inquisitive mind can in this state receive no answer. Why do we all exist? Why was the world created? Why was it not created sooner?

BOSWELL: My father, Lord Auchinleck made me become a Lawyer. My first client was a Mr John Reid, who had been accused of stealing sheep from a farm in the Borders of Scotland, if found guilty he would have been hanged, I did manage to get this gentleman's acquittal, but eight years later he was found guilty of the same offence, and he was sentenced to death. I had become emotionally attached to Mr Reid.

JOHNSON: When a man knows he is to be hanged in a fortnight, it concentrates his mind wonderfully.

BOSWELL: I appealed for a stay of execution, and a Royal pardon, but all failed. I spent hours with Mr Reid in his cell, and accompanied him to the gallows, I was hoping to cut the body down, and have him resuscitated by a surgeon, but sadly the man was beyond recall. This incident affected me deeply. One of my colleagues said to me, 'God Bless you with one of the best hearts that a man ever had.' From that moment on I found distraction in public executions, I became obsessed with death and oblivion, and would often visit prisoners just before they were taken to the gallows. I watched their chains being

removed. I often think what I would do in a similar position. I then liked to see the bodies cut down, and examine their faces. My thoughts became disturbed by the knowledge that they were sentenced by a Judge, just like my father, and vainly defended by a barrister such as myself. Do you think the fear of death is something we can get over? David Hume said he was no more uneasy to think he should not be after this life, than that he had not been, before he began to exist.

JOHNSON: Sir, if he really thinks so, his perceptions are disturbed. He is mad, if does not think so, he lies. He may tell you, he holds his finger in the flame of a candle, without feeling pain, would you believe him? When a man dies he gives up all he has.

BOSWELL: The actor Foote, Sir, told me that when he was very ill he was not afraid to die.

JOHNSON: Sir, it is not true. Hold a pistol to Foote's breast, or to Hume's breast, and threaten to kill them and see how they behave.

BOSWELL: But may we not fortify our minds for the approach of death?

JOHNSON: No, Sir. Let it alone. It matters not how a man dies, but how he lives. The act of dying is not of importance, it lasts such a short time. A man knows it must be so, and submits. It will do him no good to whine.

BOSWELL: But, Sir…

JOHNSON: Bozzy! Bozzy!

BOSWELL: I felt an irresistible impulse to be present at every execution, as I there behold the various effects of the near approach of death. I would often go and find a prostitute while the bodies were still hanging. To banish the image of death I would try and affirm my own vitality.

JOHNSON: But every man is tempted, when he is drawn away by his own lust, and enticed.

BOSWELL: It is very curious to think that I have now been in London several weeks without ever enjoying the delightful sex, although I am surrounded with numbers of free hearted ladies of all kinds, for the splendid Madam at fifty guineas a night, down to the civil nymph with white thread stockings who tramps along the Strand and will resign her engaging person to your honour for a pint of wine and a shilling, however, I am upon a plan of economy, and therefore cannot be at the expense of first rate dames. I have suffered severely from the loathsome distemper gonorrhoea, and therefore shudder at the risk of having it again, it is ghastly.

JOHNSON: Sir you really should not think of stooping so far as to make a most intimate companion of a grovelling-minded, ill bred, worthless creature.

BOSWELL: On the last occasion at the bottom of Haymarket I picked up a strong, jolly young damsel and taking her under the arm I conducted her to Westminster Bridge, and then in armour complete did I engage her upon this noble edifice. The whim of doing it there with the Thames rolling below us, amused me much. Yet after the brutish appetite was sated, I could not but despise myself for being so closely united with such a low wretch. After these events I would often feel that I had committed a heinous sin.

JOHNSON: No, Sir, it is not a heinous sin. A heinous sin is that for which a man is punished with death or punishment. But, Sir, observe the word whoremonger. Every sin, if persisted in, will become heinous. Whoremonger is a dealer in whores, as an ironmonger is a dealer in iron. But as you don't call a man an ironmonger for buying and selling a penknife, so you don't call a man a whoremonger for getting one wench with child. Sir, much more misery than happiness, upon the whole, is produced by illicit commerce between the sexes.

There is a pause.

BOSWELL: But in times of melancholy also I would often take to prostitutes.

JOHNSON: What next? What next? Hodge! Hodge! My dear Bozzy, let's have no more of this, you'll make nothing of it and we have company. I'd rather have you whistle a Scotch tune. Fetch Mrs Williams! Now! Say we have more than usual for tea.

Life may be a pill which none of us can bear to swallow without gilding, but mere existence is so much better than nothing, that one would rather exist even in pain than not exist. Annihilation is nothing, it is the apprehension of it, which is dreadful. It is in the apprehension of it that the horror of annihilation exists.

My dictionary defines melancholy as 'A disease supposed to proceed from an abundance of black bile', but it is better known from too heavy and too viscid blood; its cure is in evacuation, nervous medicines and powerful stimuli.

MELANCHOLY; A kind of madness in which the mind is always fixed on one object.

Also a gloomy pensive discontented temper.

Also a lazy frost, a numbness of the mind.

Some men, and very thinking men, have not these vexing thoughts. Sir Joshua Reynolds is the same all year round. But I believe most men have them in a degree in which they are capable of having them. Melancholy should be diverted by every means, but not by drinking. I inherited my melancholy from my father. He was born with a serious constitutional melancholy, a morbid disposition of both body and mind. Aggravated as this was by money troubles and a wife who harped on them. It was as if in the most solid rock, veins of unsound substance are often discovered, the effects of which are well known to be a weariness of life.

BOSWELL: 'How weary, stale, flat and unprofitable,
Seem to me all the uses of the world.'

JOHNSON: You Sir, are always complaining of melancholy,
and I conclude from these complaints that you are fond of
it.

BOSWELL: Sir, you have read my essays in *The Literary
Magazine.* I have written with great sensibility on this
subject.

JOHNSON: No man talks of that which he is desirous to
conceal, and every man desires to conceal that of which
he is ashamed. Make it an invariable and obligatory law to
yourself, never to mention your own mental illness, if you
are never to speak of them, you will think little on them,
and if you think little of them, they will molest you rarely.

BOSWELL: 'Cowards die many times before their deaths;
The valiant never taste of death but once.'

JOHNSON: What holds you Sir?

BOSWELL: I am frightened Sir.

JOHNSON: Alarmed? At what Sir?

BOSWELL: At Mrs Williams Sir. She is so peevish, Sir. So
difficult.

JOHNSON: *(Addressing the audience.)* The ladies in my company
Sirs, have always been a problem. Mrs Williams hates
everyone, Levitt hates Desmoulin, and does not love Mrs
Williams, Desmoulin hates them both, Poll Carmichael
loves none of them. Poll is a stupid slut, I had some hopes
for her at first, but when I talked to her tightly and closely,
I could make nothing of her, she was all wiggle waggle,
and I could never persuade her to be categorical. Fetch
Mrs Williams Sir! I do not overvalue the comforts which I
have received from my friendship with Anna Williams.

BOSWELL exits.

MRS WILLIAMS enters with tea.

JOHNSON: Ah, here is Mrs Williams.

MRS WILLIAMS: Too many people Dr Johnson, I am a poor blind lady from Wales. Too many people for tea. Puss, puss, puss. Puss, puss, puss. Where is that Hodge?!

MRS WILLIAMS begins to dish the tea out to the audience. After pouring each cup she stick her finger in to check the level.

MRS WILLIAMS: My finger is quite clean, do not be alarmed. One needs to make sure you get a full cup, we do not want any complaints in such a house. Puss, puss, puss.

JOHNSON: Dear Mrs Williams came to London to cure a cataract, the operation sadly went wrong, and she ended up blind. The daughter of an ingenious surgeon, and a lady of letters and literature, she is great company, to a poor man. Thank you Mrs Williams. A decent provision for the poor is the true test of civilization.

MRS WILLIAMS: Puss, puss, puss. Now. Tea. Tea. Tea is better than drink, Doctor, for what pleasure can men make in making beasts of themselves?

JOHNSON: I wonder Madam, that you have not penetration enough to see the strong inducement to this excess, for he who makes a beast of himself gets rid of the pain of being a man.

MRS WILLIAMS: But to argue the other case, I cannot think, Sir why you reject a harmless glass of wine. It is balm to the spirit and a spur to the conversation.

JOHNSON: I know of no good that it does whatsoever.

MRS WILLIAMS: But, Sir, it makes a man eloquent.

JOHNSON: I think, Madam, it makes a man noisy and absurd.

MRS WILLIAMS: This you must allow, Sir, it makes a man speak the truth.

JOHNSON: I see no good there is in either, Madam, unless he is a liar when he is sober. Wit is wit, by whatever means it is produced, and if good, will appear so at all times. I admit that the spirits are raised by drinking, as by the common participation of any pleasure. Cock fighting or bear baiting will raise the spirits of a company, as drinking does, though surely they will not improve conversation. I also admit that there are some sluggish men who are improved by drinking, as there are fruits which are not good until they are rotten. There are such men, but they are medlars. One of the disadvantages of wine is that it makes a man mistake words for thoughts. Wine makes a man more pleased with himself; I do not say it makes him more pleasing to others.

MRS WILLIAMS (finishes making the tea and) exits.

JOHNSON: We all live together in ferocious mutual hostility. Does any of the present company lay claim to the title of being married? My condolences. Especially if it is for the second time, the triumph of hope over experience. My own father and mother had not much happiness from each other. They seldom conversed for my father could not bear to talk of anything but his affairs. He was a bookseller, and my mother being unacquainted with books cared for anything but… Had my mother been more literate, had they been better companions. A man of sense should meet a suitable companion in a wife, it is a miserable thing when the conversation could only be such as whether the mutton should be boiled or roasted. And probably there will be a dispute about that. When people came to visit, my father became very tender to me. When I was three I was taken to London to be touched by Queen Anne for Scrofula. Royal personages were believed to possess healing powers. My mother pregnant with my brother Nathanial travelled the hundred miles to London by stagecoach and returned in an open wagon. My mother said it was because my cough was too violent but I think she wanted to save money. She sewed two guineas into the hem of her petticoat for fear of being robbed. She bought me a silver

spoon and cup, marked SAM J., for if she had marked it SJ it might have been mistaken for hers and taken from me at her death. She also bought me a speckled linen frock which I knew as my London frock. I don't have the frock or the cup, but I still have the spoon. The cup was sold when my wife Tetty and I were suffering financial stress early in our marriage.

When I was little I accidentally trod on a duckling, and my father said I made up an epitaph for the poor dead bird.

'Under this stone lies Mr Duck,
Whom Samuel Johnson trod on,
He might have lived had he more luck,
But then he'd have been an odd 'un.'

I shudder even now to speak that ditty. Tetty was my first wife. I met her in Birmingham. She was married to an unsuccessful draper Harry Porter. She was called Elizabeth but I called her just Tetty, or Tetsey. She had three children. She was kind to me, and twenty years older than me, and used to say that I was the most sensible man she had ever met in her life. Nothing flatters a man as much as the happiness of his wife; he is always proud of himself as the source of it.

Enter BOSWELL.

BOSWELL: David Garrick described Tetty as fat, with a bosom of more than extraordinary exuberance, with swelled cheeks of a florid red, produced by thick painting, and increased by the liberal use of cordials, flaring and fantastic in her dress, and affected both in her speech and general behaviour. I used to see Garrick exhibit her, by his exquisite talent of mimicry, so to excite the heartiest bursts of laughter. Poor Johnson.

BOSWELL pinches JOHNSON's cheek.

JOHNSON: I have never liked vapid women with no opinion. They have softness, but so do pillows. I do not respect

empty-headed prettiness. Tetty took opium for relief and would often take to her bed with romantic fiction.

BOSWELL: *(Addressing the audience.)* How I first met the good Doctor.

On Monday the 16th of May 1763, I was drinking tea at Davies's in Russell Street, and at about seven came in the great Samuel Johnson, whom I had longed to meet. Mr Davies announced his aweful approach to me, somewhat in the manner of an actor in the part of Horatio, when he addresses Hamlet on the appearance of his father's ghost, 'Look my Lord, it comes.' As I knew of a mortal antipathy he had towards the Scots, I cried to Davies, "Don't tell him where I am from." However, the Doctor said:

JOHNSON: You are from Scotland?

BOSWELL: Indeed, I come from Scotland, I cannot help it.

JOHNSON: Sir, that I find is what a great many of your countrymen cannot help. Sir.

BOSWELL: But you must allow, Sir, that Scotland has many noble wild prospects.

JOHNSON: Sir, you have a great many. Norway too has noble wild prospects, and Lapland is remarkable for prodigious wild prospects. The noblest prospect of a Scotchman Sir, is the high road that leads him to England.

BOSWELL: *(Addressing the audience.)* On meeting Johnson for the first time I thought his appearance dreadful, troubled with sore eyes, the palsy, and the King's Evil, which are scars from scrofula, he speaks with a most uncouth voice. Yet his great knowledge and strength of expression command vast respect and render him very excellent company. He has great humour and is a worthy man, but his dogmatical roughness of manners is disagreeable.

Sam Johnson's mind resembles the vast amphitheatre, the Coliseum at Rome. In the centre stands his

judgement, which like a mighty gladiator, combated those apprehensions that, like the wild beasts of the Arena, were all around in cells, ready to be let upon him. And after a conflict he drives them back into their dens.

JOHNSON takes some orange peel from his pocket and looks at it. And puts it in his other pocket. He shows it to BOSWELL.

BOSWELL: O, Sir, I now partly see what you do with the squeezed oranges which you put into your pocket at the Club.

JOHNSON: I have a great love for them.

BOSWELL: And pray Sir, what do you do with them? You scrape them, it seems, very neatly and what next?

JOHNSON: I let them dry Sir.

BOSWELL: And what next?

JOHNSON: Nay Sir, you shall not know their fate further.

BOSWELL: Then the world must be left in the dark. It must be said, he scraped them, and let them dry, but what he did with them next he never could be prevailed upon to tell.

JOHNSON: Nay, Sir, you should say it more emphatically, he could not be prevailed upon, even by his dearest friends to tell. But you I will tell all. This is for my health, I save the peel and dip it into red hot port, it soothes me. I also take opium, valerian, ipecacuanha, salts of hartshorn, musk, dried sqills and Spanish fly. I am bled for my eye infection, and for flatulence.

DR JOHNSON farts.

BOSWELL: Johnson, though he could be rigidly abstemious, was not a temperate man either in eating or drinking. He could refrain, but he could not use moderately.

JOHNSON takes out his dictionary. There is a pause. JOHNSON thinks.

JOHNSON: The morality of an action depends on the motive from which we act. If I fling half a crown to a beggar with the intention to break his head, and he picks it up and buys victuals with it, the physical effect is good, but with respect to me the action is very wrong. So religious exercises, if not performed with an intention to please God, avail us nothing.

Some people have a foolish way of not minding, or pretending not to mind, what they eat. For my part, I mind my belly very studiously, and very carefully; For I look upon it, that he who doesn't mind his belly will hardly mind anything else. A man is in general better pleased when he has a good dinner upon his table, than when his wife talks Greek.

BOSWELL: Good living, and eating well, I suppose, makes the Londoners strong.

JOHNSON: Why, Sir, I don't know what it does. Our chairmen from Ireland, who are as strong men as any, have been brought up on potatoes. Quantity makes up for quality. A man seldom thinks with more earnestness of anything than he does of his dinner.

JOHNSON eats.

BOSWELL: I must tell you, that when at a table, eating, Dr Johnson is totally absorbed in the business of the moment, his looks are riveted to his plate, nor will he, unless when in very high company, say one word, or even pay the least attention to what was said by others. While in the act of eating the veins on his forehead swell and generally a strong perspiration is visible. It is quite a sight.

JOHNSON: What do you think of the actor David Garrick? He has refused me an order for the play for myself and Mrs Williams. Mr Garrick knows the house will be full, and that an order would be worth three shillings.

BOSWELL: Oh Sir, I cannot think Mr David Garrick would grudge such a trifle with you…

JOHNSON: *(Interrupting sternly.)* Sir, I have known David Garrick longer than you have done, and I know no right you have to talk to me on the subject. *(To the audience.)* I was a teacher Sirs, which I found as unvaried as the cuckoo, and David Garrick was my pupil. I do not know whether it was more disagreeable for me to teach, or for the boys to learn grammar. After a time the school was not doing well, and it was then that I wrote my first play 'Irene and the Sultan Mohamed'. Garrick and I decided to walk to London to seek our fortunes. We walked the one hundred and eighteen miles to London, sharing a horse, one would ride while the other would walk, and in this manner we arrived in London.

BOSWELL: Did you not mention the great Garrick in your preface to Shakespeare?

JOHNSON: Yes, as a 'poor player who frets and struts his hour upon the stage…' as a shadow.

BOSWELL: But has he not brought Shakespeare to notice?

JOHNSON: Sir, to allow that would be to lampoon the stage. Many of Shakespeare's plays are the worse for being acted. Macbeth for instance.

BOSWELL: Why Sir, when Garrick re-entered with the bloody dagger I was absolutely scared out of my senses.

JOHNSON: What senses, Sir?

BOSWELL: Sir, is there not something to be gained by decoration and action? Indeed Sir, I wish you had mentioned Garrick.

JOHNSON: My dear Sir, had I mentioned him, I must have mentioned many more, Mrs Pritchard, Mrs Cibber, nay, and Mr Cibber too, he too altered Shakespeare. Mrs Cibber was the most exquisite and tender of Ophelias and Juliets.

BOSWELL: But Garrick is a clever fellow, Dr Johnson. Garrick, take him altogether, is certainly a very great man.

JOHNSON: Garrick, Sir, may be a great man in your opinion, but he is not so in mine. *(To the audience.)* Little things are great to little men. Take the singing witches in Macbeth, Sirs. Garrick dressed them in the most charming costumes, some of white satin and lace, and they were rouged and powdered and made to look as attractive as possible. It was flummery Sir, mere flummery.

BOSWELL: But I have heard you say, Dr Johnson…

JOHNSON: *(Interrupting.)* Sir you have never heard me say that David Garrick was a great man. You may have heard me say that Garrick was a good repeater, of other men's words. Words put into his mouth by other men. This makes but a faint approach towards being a great man.

BOSWELL: But take Garrick upon the whole, now, in regard to our conversation.

JOHNSON: *(Interrupting.)* Well, Sir, in regard to conversation, I never discovered in the conversation of David Garrick any intellectual energy, any wide grasp of thought, and extensive comprehension of mind, or that he possesses any of those powers to which great could, with any degree of propriety, be applied. Garrick certainly emulates erudition, but almost every man wastes part of his life attempting to display qualities which he does not possess.

BOSWELL: But still…

JOHNSON: *(Interrupting.)* Hold Sir! I have not done talking. There are, to be sure, in the laxity of colloquial speech, various kinds of greatness. A man may be a great tobacconist, a man may be a great painter, he may be likewise a great mimic. And I will allow that Garrick may be a great imitator. To be a good mimic, requires great powers, great acuteness of observation, great retention of what is observed, and great pliancy of organs, to represent what is observed.

JOHNSON takes out his dictionary.

MIMIC; A ludicrous imitator; a buffoon who copies another's act or manner as to excite laughter.

No man was ever great by imitation.

BOSWELL: You do not see Mr Garrick as much as you were wont.

JOHNSON: I am unable to go backstage at Drury Lane to see Mr Garrick, as the silk stockings and the white bubbies of the actresses excite my amorous propensities.

BOSWELL: But Sir, you must allow Garrick has…

JOHNSON: Enough. Garrick is my property. I will not suffer anyone to praise or abuse him, but me. Enough!

BOSWELL exits.

SIR JOSHUA REYNOLDS enters. He is perturbed.

JOSHUA REYNOLDS: I have been thinking Dr Johnson.

JOHNSON: Ah. Sir Joshua Reynolds. I was just thinking of you. Are we done with pleasantries?

JOSHUA REYNOLDS: Please let me continue Sir. I have something to say. It has been on my mind for some time.

JOHNSON: *(Winking at the audience.)* Why of course Sir. Please do go on. Pray, do go on.

JOSHUA REYNOLDS: I have been thinking, Dr Johnson, this morning, on a matter that puzzled me very much, it is a subject that I dare say has often passed in your thoughts, and though I cannot, I dare say you have made up your mind on it.

JOHNSON: Tilly fally, what is all this preparation, what is all this mighty matter?

JOSHUA REYNOLDS: Why, it is a very weighty matter. The subject I have been thinking upon, predestination

and free will, two things I cannot reconcile together for the life of me, in my opinion, Dr Johnson, free will and foreknowledge cannot be reconciled.

JOHNSON: Sir, it is not of very great importance what your opinion is upon such a question.

JOSHUA REYNOLDS: But I meant only, Dr Johnson, to know your opinion.

JOHNSON: No, Sir, you meant no such thing, you meant only to show these gentleman that you are not the blockhead they took you to be, but that you think of high matters sometimes, and that you may have the credit of having it said that you held an argument with Sam Johnson on predestination and freewill, a subject of that magnitude as to have engaged the attention of the world, to have perplexed the wisdom of man for these two thousand years. That such a subject could be discussed in the general levity of convivial conversation, is a degree of absurdity beyond what is easily conceivable.

JOSHUA REYNOLDS: It is so, as you say to be sure. I talked once to our friend Garrick upon this subject, but I remember we could make nothing of it.

JOHNSON: Hah. Oh a noble pair!

JOSHUA REYNOLDS: Sir, Garrick told me…

JOHNSON: (Interrupting.) No, Sir. I assure you we have done with Garrick in this company.

JOSHUA REYNOLDS: But Garrick as a companion, I heard you say, no longer than last Wednesday, at Mr Thrale's table…

JOHNSON: (Interrupting.) You tease me, Sir. Whatever you may have heard me say, no longer than last Wednesday, at Mr Thrale's table, I tell you I do not say so now, besides, as I said before, you may not have understood me, you misapprehended me, you may not have heard me.

JOSHUA REYNOLDS: I am very sure I heard you.

JOHNSON: Besides Sir, besides, do you not know, are you so ignorant as not to know, that it is the highest degree of rudeness to quote a man against himself?

JOSHUA REYNOLDS: But if you differ from yourself, and give one opinion today, and another...

JOHNSON: *(Interrupting.)* Have done Sir! The company you see are tired, as well as myself. Please leave.

JOSHUA REYNOLDS: But Sir...

JOHNSON: *(Interrupting.)* Enough! Get out. Now!

JOSHUA REYNOLDS exits, scolded.

JOHNSON opens his dictionary.

JOHNSON: Blockhead; A stupid fellow, a dolt, a man without parts.

It is better to be remain silent and be thought a fool, than open one's mouth and remove all doubt.

I hate a fellow whom pride, or cowardice, or laziness drives into a corner, and who does nothing when he is there but sit and growl. Let him come out as I do, and bark.

BOSWELL and JOSHUA REYNOLDS have a conversation offstage.

JOSHUA REYNOLDS: I declare Bozzy, I had rather be tossed by a ball, than remain in a room with Dr Johnson when he is in a temper.

BOSWELL: Consider my dear friend, last week only he tossed me in company at Mr Thrale's.

JOSHUA REYNOLDS: Oh, Bozzy, however well I know his habits I have no stomach to endure them.

BOSWELL enters.

BOSWELL: *(Addressing the audience.)* Dr Johnson is like a warm West Indian climate, where you have bright sun, quick vegetation, luxuriant foliage, luscious fruits, but where the same heat sometimes produces thunder, lightning, and earthquakes in a terrible degree. Sir, you were rude to poor Joshua Reynolds.

JOHNSON: Don't talk of rudeness, we have done with civility. We are to be as rude as we please.

BOSWELL: I do not think he meant to be uncivil.

JOHNSON: Well I did mean to be uncivil. Sir Reynolds is a ninnyhammer!

BOSWELL: *(To JOHNSON.)* Sir, you made me very uneasy by your behaviour towards me when we were last at Sir Joshua Reynolds'. You know, my dear Sir, no man has greater respect and affection for you, or would sooner go to the end of the world to serve you. Now to treat me so..

JOHNSON: *(Interrupting.)* You interrupted me at Sir Joshua's.

BOSWELL: That is not the case. Why treat me so before people who neither love you, nor me?

JOHNSON: Well I am very sorry for it. I'll make it up to you twenty different ways, as you please.

BOSWELL: I said just now to Sir Joshua, when he observed that you tossed us both sometimes, that I don't care how often or how high you toss me when only friends are present, for then I fall upon soft ground, but I do not like falling on stones, which is the case when enemies are present. I think this is a pretty good image Sir.

JOHNSON: Sir, it is one of the happiest I have ever heard.

BOSWELL: I then yearn to be away from London and at my Estate in Auchinleck.

JOHNSON: And still you write, Sir.

BOSWELL: I do indeed, Sir.

JOHNSON: But what I say is of small note Sir.

BOSWELL: Sir, nor is it always in the most distinguished achievements that men's virtues or vices may be best discerned, but very often an action of small note, a short saying, a jest, shall distinguish a person's real character more than the greatest sieges, or the most important battles.

JOHNSON: It is true Sir that biography has often been allotted to writers who rarely afford any other account than might be collected from public papers, when they exhibit a chronological series of action or preferments; and have so little regard to the manners or behaviour of their heroes, that more knowledge may be gained of a man's real character, by a short conversation with one of his servants, than from a formal and studied narrative, begun with his pedigree, and ended with his funeral.

BOSWELL: The incidents which give excellence to biography are of a volatile and evanescent kind, such as soon escape the memory.

JOHNSON: You speak well, Sir, and still you write our conversations. Surely some may object?

BOSWELL: I am fully aware Sir, of the objections which may be made to the minuteness of my detail of your conversations, but I remain firm and confident in my opinion, that minute particulars are frequently characteristic, and always amusing, when they relate to a distinguished man.

JOHNSON: Still you continue Sir on the writing of my life? Even though much of what I say is idle?

BOSWELL: Even idle talk of a good man, Sir, ought to be regarded, the most superfluous things he saith are always of some value.

JOHNSON: So you shall continue with writing our conversations Sir?

BOSWELL continues to write in his notebook.

JOHNSON: You do not think your task presumptuous?

BOSWELL: I think to write the life of a man such as yourself who has excelled in all mankind a little presumptuous Sir. I have left my Hebridean journal with Mrs Thrale.

JOHNSON: Do you intend Sir to prove that you are the best candidate to write my life Sir? I advised you not to show the Journal to anyone, until I have looked it over.

BOSWELL: Mrs Thrale has sent them back Sir. She only reached the Isle of Coll. She said they were 'entertaining', but she was blinded by the crammed pages.

JOHNSON: My trip to Paris with the Thrales was disappointing, as I did not have you to animate the scenes Bozzy. I have no great pleasure in seeing one church, palace, and private house after another. France is worse than Scotland in everything but climate. Nature has done more for the French, but they have done less for themselves that the Scotch have done. I do think Bozzy that you have a talent, a genius in recording and presenting conversation.

BOSWELL: Thank you Sir. If it not troublesome, I would request you to tell me all the little circumstances of your life? Do you disapprove of my curiosity to ask these particulars?

JOHNSON: My dear Bozzy, they will come out in degrees as we talk together. The happiness of London is not to be conceived but by those who have been in it. I will venture to say, there is more learning and science within the circumference of ten miles for where we now sit, than in all the rest of the Kingdom. Auchinleck included.

BOSWELL: The only disadvantage of London is the great distance at which people live from one another.

JOHNSON: Yes, Sir, but that is occasioned by the largeness of it, which is the cause of all the other advantages.

JOHNSON and **BOSWELL:** He who is tired of London is tired of life.

JOHNSON: By seeing London I have seen as much of life as the world can show.

BOSWELL: Sometimes I have been in the humour of wishing to retire and find peace in Scotland.

JOHNSON: Indeed Sir, you have desert enough in Scotland.

BOSWELL: I think, Sir that you are harsh towards the Scots.

JOHNSON: Do you think so, Bozzy? Then I give you leave to say, and you may quote me for it, that there are more gentleman in Scotland than there are shoes.

BOSWELL: And what else of Scotland Sir?

JOHNSON: Please Sir, do not bore me with your nostalgic sentiments.

BOSWELL: A Scot has the right to be nostalgic.

JOHNSON: Sir. Do not talk to me of your nostalgia, or your independency, who could let your Queen remain twenty years in captivity, and then be put to death, without even a pretence of justice, without your ever attempting to rescue the poor wretch, and such a Queen too! As every man of any gallantry of spirit would have sacrificed his life for.

BOSWELL: Half our nation was bribed by English money.

JOHNSON: Sir, that is no defence, sadly that makes you worse.

BOSWELL: We had better say no more about it.

JOHNSON: Sir, any country that has at church doors, a sign in large letters saying CLEAN YOUR FEET deserves to be on its own.

JOHNSON takes out his dictionary.

JOHNSON: O<small>ATS</small>; A grain which in England is generally given to horses, but in Scotland supports the people.

BOSWELL: I am thinking Sir of buying St. Kilda, the most remote island of the Hebrides.

JOHNSON: Pray do Sir. We will go and pass a winter amid the blasts there. We shall have fresh fish, and we will take some dried tongues with us, and some books. We will have a strong built vessel and some Orkney men to navigate her. Consider, Sir, by buying St. Kilda, you may keep the people from falling into worse hands. I'll be your Lord Chancellor, or what you please. But Sir, we should visit your Empire.

BOSWELL: Are you serious, Sir, in journeying with me to the Western Isles?

JOHNSON: Why yes Sir, I am serious.

BOSWELL: Why then, I'll see what can be done. *(Addressing the audience.)* Dr Johnson had said for many years that we should go together and visit the Hebrides.

JOHNSON: *(To the audience.)* I had desired to visit the Hebrides, or Western Isles of Scotland, so long that I scarcely remember how the wish was originally excited, my father gave me a book when I was very young, Martin's description of The Western Isles of Scotland. But inwardly I feared that seeing Scotland would only be seeing a worse England. It is seeing the flower gradually fade away to a naked stalk. But seeing the Hebrides, indeed, was quite a different scene.

BOSWELL: In 1764, I mentioned to Voltaire, about our trip to the Hebrides. He looked at me as if I had talked about going to the North Pole, and said, 'You do not insist on me accompanying you?' 'No Sir' said I, 'Then I am very willing that you should go?

JOHNSON: 'For who would leave, unbrib'd Hibernia Land? Or change the rocks of Scotland for the Strand?

There none are swept by sudden fate away:
But in quiet contemplation spend the day.'

Samuel Johnson is indignant! That Scotland has so few trees! I felt great distress for the Highlanders, and was shocked at the bad management of the ground and the neglect of timber in the Hebrides.

BOSWELL: My dear friend, lost his stout walking stick and could not be persuaded from the suspicion that it had been stolen.

JOHNSON: No, no my friend it is not to be expected that any man in Mull who got my stick would ever part with it. Consider, Sir, the value of such a piece of timber! Why you have as little timber in Scotland as you have privés!

BOSWELL: One afternoon we drove over the very heath where Macbeth met the witches, according to tradition...

JOHNSON: *(Solemnly.)* 'How far is't called to Forres? What are these,
So wither'd, and so wild in their attire?
That look not like the inhabitants o' the earth,
And yet are on't?'

Not, Sir, bewigged and powdered like Garrick's witches.

BOSWELL: He then parodied the 'All hail' of the witches to Macbeth, addressing himself to me. I had purchased some land in Dalblair, thus had two titles, Dalblair, and young Auchinleck.

JOHNSON: *(Laughing.)* 'All hail, Dalblair! Hail to thee, Lord of Auchinleck!'

BOSWELL: On August the twenty-ninth, we went to Macbeth's castle, I had such romantic satisfaction in seeing Dr Johnson in it. Just as we came out of it, a raven perched on one of the chimney pots, and croaked.

JOHNSON: 'The raven himself is hoarse,
That croaks the fatal entrance of Duncan,
Under my battlements.'

BOSWELL: But Sir, is it not true that the Scots make the best gardeners?

JOHNSON: Why, Sir, that is because gardening, is much more necessary amongst you than with us, which makes so many of your people learn it. It is all gardening with you. Things which grow in England here must be cultivated with great care.

BOSWELL: May I boast Sir, that it was the Scots that were the first to abolish the inhospitable, troublesome, and ungracious custom of giving veils to servants.

JOHNSON: Sir, you abolished veils because you were too poor to be able to give them. We were unlucky enough to be stuck on Skye, for the whole of September, due to bad weather. I had the honour of saluting the far-famed Lady Flora MacDonald. We were of course curious to hear the story of 'The Pretenders' journey over the sea to Skye.

BOSWELL: Bonnie Prince Charlie, not 'The Pretender', as a patriot I consider that is an insult Sir, from the English.

JOHNSON: PATRIOTISM; Love or zeal for one's country.

It was eight years since the defeat and exclusion of Charles Edward Stuart, and on our trip to the Highlands I had hoped to find a thriving tribal society, but the Chiefs had already lost much of their influence, and they had degenerated from patriarchal rulers to rapacious landlords.

BOSWELL: It was fine to see Mr Johnson alight from his horse at Lord Kingsburgh's who received us most courteously, and after shaking hands, he supported Mr Johnson into the house.

JOHNSON: Kingsburgh was quite the figure of the gallant Highlander. 'The gracefu' mien and manly looks' which

your popular Scotch song, 'The Highland Laddie', has justly attributed to his character.

BOSWELL and JOHNSON sing 'The Highland Laddie'.

BOSWELL AND JOHNSON:
The lowland lads think they are fine
But O' they are vain and idly gaudy
How much like that gracefu' mien
And manly looks of my Highland laddie

Oh my bonnie, bonnie Highland laddie.
Oh my bonnie, bonnie Highland laddie.
When I was sick and like to die.
He rowed me in his Highland plaidie.

JOHNSON: There was a comfortable parlour with a good fire, and a flask of Hollands gin went round. By and by supper came, when there appeared his spouse, the celebrated Miss Flora.

BOSWELL becomes LADY FLORA MACDONALD.

FLORA: I Am Lady Flora MacDonald

FLORA becomes BOSWELL, etc.

BOSWELL: She was a little woman of middle years and of a mild and genteel appearance, mighty soft and well bred.

JOHNSON stands and bows very low.

JOHNSON: We had as genteel a supper as one would wish to see, in particular an excellent roasted turkey.

BOSWELL: We stayed to drink at the table, and after the supper claret and punch. Johnson was delighted at this and highly entertained. The room where we lay in Skye, was a room indeed.

JOHNSON: Each bed had tartan curtains.

BOSWELL: And Dr Johnson's bed was the one in which Bonnie Prince Charlie lay. To see Dr Johnson lying in

Prince Charles's bed, in the Isle of Skye, in the house of Miss Flora MacDonald, was a wonderful and romantic scene to me.

We hear 'The Lone Piper.' BOSWELL exits.

JOHNSON: It was here that the Prince slept having escaped the red coats after the Battle of Culloden which ended so brutally, his brave attempt to reclaim the English Crown for the Stuarts in 1745. I slept soundly in his bed and I had no ambitious thoughts. At breakfast I spoke of the Prince...

LADY FLORA MACDONALD enters.

I asked the Lady of the house the burning question.

(Addressing LADY FLORA MACDONALD.) We were told in England that there was one Flora MacDonald with him, when he escaped?

FLORA MACDONALD: They were very right. When it was known that the Prince was at Uist and the country was full of English troops and the coast was surrounded with ships I agreed to smuggle the Prince out. We passed him as my supposed maid, an Irish girl, Betty Bourke. We set off in a small boat, a shot was fired from the mainland to bring us to. My uncle, Hugh MacDonald was commander of the local militia searching for the Prince and it was he who had given me a pass to cross to Skye with my maid, Betty Bourke, a manservant and the six boatsmen. So all was well and we landed at Skye. I got a horse and my maid, Betty, walked beside me as is the custom in our part of the world. Bonnie Prince Charlie, the young pretender, scourge of the English army who had commanded six thousand men at one point in the rebellion now walked beside me dressed as Betty and looking somewhat awkward in women's clothes.

After dinner I rode on horseback towards the shore with Betty Bourke and my Father Lord Kingsburgh and the servant carrying some linen all on foot. We proceeded towards my Kingsburgh House. Upon the road was a small

rivulet which we obliged to cross. The Prince forgetting his assumed sex, that his clothes might not be wet held them up a great deal too high. I mentioned this to him, observing it might make a discovery, he said he would be more careful for the future, he was as good as his word for the next brook they crossed, he did not hold up his clothes at all, but let them float on the water, he was very awkward in his female dress... his size was too large and his stride too great that some woman reported that they had seen a very big woman, that looked like a man in woman's clothes, and that perhaps it was the Prince they were making such search for.

Back at Kingsburgh House we met with a most cordial reception, and he seemed gay at supper, and after indulged himself in a cheerful glass with his worthy host. As he had not had his clothes off for a long time, the comfort of a good bed was highly relished by him, and he slept soundly until the next day at one o' clock. In the morning old Kingsburgh was woken by my mother who told him that they should rouse the Prince as she feared a party of soldiers might come and arrest him. Old Kingsburgh said, 'Let him repose himself after his fatigue; and as for me, I care not if they take off this old grey head!' He pulled off his nightcap and showed it. He then pulled the bedclothes over him and went back to sleep. Sweet are the slumbers of the virtuous man. My mother after the Prince had left took the sheets in which he had lain, folded them carefully and charged me that they should be unwashed, and that when she died, her body should be wrapped in them as a winding sheet. Her will was religiously observed.

JOHNSON: Yet I must add, if the gesture of holding up my right hand would have secured victory at Culloden to your Prince Charles's army, I am not sure I could have done it. I have very little confidence in the right claimed by the house of Stuart, and I am so fearful of the consequences of another revolution on the throne of Britain.

LADY FLORA: The escape of Charles Edward Stuart was much celebrated, but was also the occasion of great sorrow.

JOHNSON opens his dictionary.

JOHNSON: SORROW; Grief; pain for something past; sadness; mourning. Sorrow is not commonly understood as the effect of present evil, but of lost good.

But you were punished for your loyalty to the Prince?

LADY FLORA: Indeed Sir, but I told His Grace the Duke of Cumberland that I had acted from charity, and would have helped His Grace also had he been defeated and in distress. But I was sent for to London and imprisoned a short time in the Tower until the Act of Indemnity in 1747.

LADY FLORA MACDONALD becomes BOSWELL.

BOSWELL: Please Sir, let me see your dictionary a moment. Please. I would like to make a point. The words you spoke to Lady Flora caused me much distress.

JOHNSON: A point?

BOSWELL: *(Reading from the dictionary.)* PENSION; Pay given to a state hireling for treason to his country.

PENSIONER; A slave of trade hired to obey his country.

I understand, Sir, that three hundred pounds a year has put quietus to your Jacobitism. There have been many objections from your peers for accepting it.

JOHNSON: *(Laughing.)* Why Sir, it is a mighty foolish noise they make. I have accepted a pension as a reward which has been thought due to my literary merit, and now that I have this pension, I am the same in every respect than I have ever been, I retain the same principles.

BOSWELL: But you will no longer drink to the King over the water?

JOHNSON: I think the pleasure of cursing the House of Hanover, and drinking King James's health all amply overbalanced by three hundred pounds a year.

BOSWELL: But now Sir, we are to understand that you are intimate with his Majesty?

JOHNSON: In February 1767, there occurred the most remarkable incident in my life, which gratified my monarchical enthusiasms. I was honoured a private conversation with his Majesty at Queen's House. I had frequently attended those splendid rooms, as they had a remarkable collection of books.

KING GEORGE III enters.

KING GEORGE: I was aware of Dr Johnson's occasional visits, and requested to attend him the next time he came to read in the library.

JOHNSON: I was sat by the fire reading. I was fairly engaged with a book, and did not notice the King entering the room.

KING GEORGE: I hear, Sir, that you have lately been in Oxford. Sir, are there better libraries in Oxford or Cambridge? Which is the largest Sir, All Souls or Christ Church? What, what?

JOHNSON: All Souls is the largest we have Sir.

KING GEORGE: Are you writing anything at the moment Sir? What what?

JOHNSON: I am not Sir, I think I have pretty much told the world what I know. I think now, I have to read, and acquire more knowledge.

KING GEORGE: I have a desire, Sir, that there is a literary biography of all our poets for the nation, ably executed. I propose to you Dr Johnson that you take on the task. What, what?

JOHNSON: Of course your Majesty.

JOHNSON bows, and the KING exits.

(Addressing the audience.) They may talk of the King as they will, but he is the finest gentleman I have ever seen. His manners are those of a fine gentleman as may suppose Louis the Fourteenth, or Charles the Second. I find it does a man good to be talked to by his Sovereign.

BOSWELL: So Sir, you took the pension?

JOHNSON: Don't you consider Sir, that these are not the manners of a gentleman? I will not be baited with what and why! What is this? What is that? Why is a cow's tail long? Why is a fox's tail bushy? Sir you have but two topics, yourself and me. I am sick of both.

BOSWELL passes the dictionary to JOHNSON.

BOSWELL: But now you have completed your mighty work Sir, you must find a further occupation.

JOHNSON: One is contented instead to take up little things. Women have a great advantage, they can take up little things without disgracing themselves. A man cannot, except fiddling. Had I learnt the fiddle, I should have done nothing else. I once tried knotting, but I could not learn it. Knitting is a good amusement. As a Freeman of Aberdeen, I should be a knitter. Anything, even rope dancing.

BOSWELL: Indeed. But without an occupation you may become glum.

JOHNSON: Glum; A low cant word formed by corrupting gloom. Sullen, stubbornly grave.

BOSWELL: You should write another book, Sir.

JOHNSON: But Sir, a man must read half a library just to make one book.

BOSWELL: When we dined last week at the Thrales we were a rather strange combination, myself, Sam Johnson, Dr

Goldsmith and Sir Joshua Reynolds. Little Dr Goldmith was continually enraged that Johnson could never be worsted in an argument. He spoke very shrilly thus:

DR GOLDSMITH: Why am I always to be put down and continually argued at your dinner table, madam? No one will dispute that I am the better writer than Johnson. None will dispute that my works are more popular, that my drama plays better, that in all respects I am the superior hack. Yet that great mountain of a man, that pontificator slobbering into his chocolate, that haunch of venison out-argues and out-guns me. It is...outrageous!

JOHNSON: The misfortune of Goldsmith in conversation, is this, he goes on without knowing how he is going to get off. His genius is great, but his knowledge is small. As they say of a generous man, it is a pity he is not rich, we may say of Goldsmith, it is a pity he is not knowing. He would not keep his knowledge to himself.

DR GOLDSMITH: There is no winning with Dr Johnson. If his pistol misfires he clubs you with the butt end of it.

JOHNSON: David Garrick missed out on Goldie's play *She Stoops to Conquer*. He thought the play too low. Goldie met Horace Walpole outside the theatre where he had just seen 'She Stoops to Conquer' and had asked him his opinion. Walpole had said that he had found it a trifle low, to which Goldie replied, 'Yes, but did it make you laugh.' I take the object of comedy to increase the stock of merriment in the world, and this Goldie fulfilled admirably.

DR GOLDSMITH: Johnson to be sure has a roughness in his manner, but no man alive has a more tender heart. He has nothing of the bear but his skin. Mrs Boswell says she has seen many a bear led by a man, but never saw a man led by a bear 'til now.

DR GOLDSMITH exits.

JOHNSON: Goldie's mind resembled a fertile, but thin soil. There was a quick but not strong vegetation. No deep

root could be struck. The oak of the forest did not grow there. It has been generally circulated that he was a mere fool in conversation, but in truth, this has been greatly exaggerated. Goldie is a poet, naturalist and historian. He left scarcely any style of writing untouched, and he touches nothing that he did not adorn.

BOSWELL enters.

BOSWELL: My desire of being acquainted with celebrated men of every description had made me gain the acquaintance of Dr Samuel Johnson and to John Wilkes, Esq. Two men more different could not be selected out of all mankind. And I took there to be great political antipathy between them. Lord Sandwich had told Wilkes, "I know not whether you shall die first of the pox or the gallows", to which Wilkes replied, "That Sir depends upon whether I embrace first your mistress or your politics."

(To the audience.)

My worthy booksellers and friend, Messrs. Dilly in the Poultry, at whose hospitable and well-covered table I have not seen a greater number of literary men, than at any other, except that of Joshua Reynolds, had invited me to meet Mr Wilkes, and some other gentlemen. 'Pray, let us have Dr Johnson. Mr Edward Dilly was quite insistent, but I said that if he invited them both together I was sure Dr Johnson would never forgive him. I thought to negotiate the meeting...

BOSWELL: *(To JOHNSON.)* Mr Dilly, Sir, sends his respectful compliments to you, and would be happy if you would do him the honour to dine with him on Wednesday next along with me, as I must soon go to Scotland.

JOHNSON: Sir, I am obliged to Mr Dilly. I will wait upon him.

BOSWELL: Provided, Sir, I suppose, that the company which he is to have, is agreeable to you?

JOHNSON: What do you mean, Sir? What do you take me for? Do you think I am so ignorant of the world as to imagine that I am to prescribe to a gentleman what company he should have at his table?

BOSWELL: Perhaps he may have some of what he calls his patriotic friends with him. *(To the audience.)* By that I meant to imply Wilkes who wrote for *The Patriot.*

JOHNSON: Well, Sir, and what then? What care I for his patriotic friends? POH!

BOSWELL: I should not be surprised to find Jack Wilkes there.

JOHNSON: And if Jack Wilkes should be there, what is that to me Sir? My dear friend, let us have no more of this. I am sorry to be angry with you, but really it is treating me strangely.

BOSWELL: Pray forgive me, Sir; I meant well. Upon the expected Wednesday I called on him half an hour before dinner. I found him buffeting his books, covered with dust, and making no preparation for going abroad.

BOSWELL: *(To JOHNSON.)* Don't you recollect that we are to dine at Mr Dilly's?

JOHNSON: Sir, I did not think of going to Dilly's, I have ordered dinner at home with Mrs Williams.

BOSWELL: But my dear Sir, you know you were engaged to Mr Dilly, and I told him so. He will expect you, and will be much disappointed if you don't come.

JOHNSON: You must talk to Mrs Williams about this.

BOSWELL: *(To the audience.)*

I was in a very sad dilemma. Mrs Williams imposed such a degree of restraint upon him, and I knew her to be obstinate. I did eventually convince her to agree for Dr Johnson to attend the dinner. When I had him fairly seated in a hackney coach with me, I exulted as much as a fortune

hunter who has got an heiress into a post-chaise with him
to set out for Gretna Green.

(*Addressing the audience.*)

When we entered Mr Dilly's drawing room, Johnson found
himself in company he did not know. I kept myself snug
and silent, watching how he would conduct himself. I
observed him whispering to Mr Dilly...

JOHNSON: Who is that gentleman?

MR DILLY: Mr Arthur Lee.

JOHNSON: So, so, so, and who is that gentleman?

MR DILLY: Mr Wilkes, Sir.

JOHNSON: Ah. I see. Mr Wilkes. Ah. The great lover of
liberty.

*There is a long pause. JOHNSON looks uncomfortable, and picks
up a book.*

MR WILKES: Dinner is served.

JOHNSON: The veal looks good Sir.

MR WILKES: Pray, give me leave Sir; It is better here, a little
of the brown? Some fat Sir? A little of the stuffing? Some
gravy. Let me have the pleasure of giving you some butter.
Allow me to recommend a squeeze of this orange?

JOHNSON: I like an orange, Sir.

MR WILKES: Or maybe the lemon Sir? May have more zest.

JOHNSON: I also like a lemon, Sir.

MR WILKES: Then you shall have it, Sir.

JOHNSON: Sir, Sir, I am obliged to you, Sir.

MR WILKES: What do you think of Foote, Sir?

JOHNSON: I think Foote to be not a very good mimic. He is worth seeing Sir, but not worth going to see.

MR WILKES: A merry Andrew, he is a buffoon.

JOHNSON: But Sir, he has wit too, and is not deficient in ideas, not in fertility and variety of imagery, and not empty of reading, he has knowledge enough to fill up his part. One species of wit he has an eminent degree, that of escape. You drive him into a corner with both hands, but he's gone, Sir, when you think you have got him, like an animal that jumps over your head. That he has a great range for his wit, but he never lets truth stand between him and a jest, and he is sometimes mighty coarse. Garrick is under many restraints from which Foote is free.

MR WILKES: Garrick's wit is more like Lord Chesterfield's.

JOHNSON: The first time I was in the company with Foote was at the Fitzherberts. Having no good opinion of the fellow, I was resolved not to be pleased, and it is very difficult to please a man against his will. I went on eating my dinner, pretty sullenly, affecting not to mind him. But the dog was so very comical, that I was obliged to lay down my knife and fork, throw myself back upon the chair and fairly laugh it out. No, Sir, he was irresistible.

MR WILKES: I hear that Garrick may leave the stage? But he will play Scrub all his life, for he will be servant to all having renounced his means of living.

JOHNSON: Indeed Sir. My belief is that Davy Garrick will cling to Drury Lane like a barnacle to a rock for many years yet, but let me tell you, Garrick has given away more money than any man in England that I am acquainted with. Garrick was very poor when he began life, so when he came to have money, he probably was very unskilful in giving it away, and saved when he need not. But Garrick began to be liberal as soon as he could.

MR WILKES: But we are doubly obliged to Mr Garrick, for as a playwright together with his friend Mr Colman he has

ushered forth a new era in stage literature. For he takes his tragic heroes and heroines from among the people, whereas previously kings and nobles only had filled the tragic scene, and their comic characters come from a class that was entirely absent from the works of Congreve and Sheridan.

JOHNSON: Indeed Sir. I am certain that Colman is the creator of that terrible bore; the virtuous peasant who always carries his entire wardrobe in a coloured pocket handkerchief at the end of a stick, who is always fighting in defence of the hapless stage maiden, is eternally spouting platitudes, is eager to bestow his last shilling upon anyone in want, and always expresses joy by stamping about singing 'Ri fol di rol fiddle iddi do.' But I think this reflects no great credit upon Davy Garrick or upon Mr Colman.

MR WILKES: Sir, among all the bold flights of Shakespeare's imagination, the boldest was making Birnam Wood march to Dunsinane, creating a wood where there never was a shrub.

JOHNSON: Indeed, a wood in Scotland, ha!

MR WILKES: And I have also observed that 'The clannish slavery of the Highlands of Scotland' is the single exception to Milton's remark, 'Sweet Liberty is worshipped in all hilly countries.'

JOHNSON: Ah Milton. *Paradise Lost* is a book that once put down is very hard to pick up again. You must know, Sir, I lately took my friend Boswell and showed him genuine civilised life in an English provincial town. I turned him loose at Lichfield, my native city, that he might see for once real civility, for you know he lives among savages in Scotland, and among rakes in London.

MR WILKES: Except when he is with grave, sober, decent people like you and me. I must own to you Sir that I am no great follower of the House of Stuart, but I think a Scots King may do less harm to us than a Scots Prime Minister.

JOHNSON: Indeed the Scottish gentlemen of whom you speak is not only likely to lose us the Colonies in America, but also has accumulated an unimaginable sum for the National Debt that will plague generations to come.

MR WILKES: Do you think, Sir, that poor Old England is lost?

JOHNSON: Sir, it is not so much to be lamented that Old England is lost, as that Scots have found it.

MR WILKES exits.

BOSWELL enters.

BOSWELL: Dr Johnson later observed:

JOHNSON: It is hard to dislike a man for his principles when you are beholden to him for the civility of his manners, and for your dinner.

BOSWELL: With Mrs Thrale he was always exquisitely polite.

JOHNSON: I was in great admiration of Mrs Thrale. Bachelors have consciences, married men have wives, and by taking a second wife he pays the highest compliment to the first. By showing that she made him so happy as a married man, that he wishes to be so a second time. However, true love is the wisdom of the fool and the folly of the wise.

MRS THRALE enters.

Lovely Mrs Thrale's first daughter was christened Hesta Maria, but soon became known as Queeney, for she became the Queen of my heart. I joined in all the children's games. Listen here Mrs Thrale, you must accustom your children constantly to this; if a thing happened at one window, and they, when relating it, say that it happened at another, do not let it pass, but instantly check them, you do not know where deviation from truth will end.

MRS THRALE: Nay, this is too much. If you should forbid me to drink tea, I would comply, as I should feel the

restraint only twice a day, but little variations in narrative must happen a thousand times a day if only one is not perpetually watching.

JOHNSON: Well, Madam, you ought to be perpetually watching. It is more carelessness about truth than from intentional lying, that there is so much falsehood in the world.

MRS THRALE: I was thinking this morning, Sir, what creature you most resemble, and I have decided it is the rattle snake. I am sure you have its attractions, I think you have its venom too, and all the world know you have its rattle!

JOHNSON: We had sat down and played a game in which we had to decide which animal we were. I was an elephant, not a snake Madam.

JOHNSON takes out his dictionary.

ELEPHANT; The largest of all quadrupeds, of whose sagacity, faithfulness, prudence, and even understanding, many surprising relations are given. It is naturally very gentle, but when enraged, no creature is more terrible.

I was thinking Madam, that if we require more perfection from women than from ourselves it is doing them honour. Women do not have the same temptations as we have, they may always live in virtuous company, men must mix in the world indiscriminately.

MRS THRALE: Still Doctor, I cannot help thinking it is a hardship that more indulgence is allowed to man than to woman. It gives superiority to men, to which I do not see how they are entitled.

JOHNSON: People cannot be naturally equal, for no two people can be together for even a half hour without one acquiring an evident superiority over the other. As Shakespeare says, 'Well, God's a good man – an two men ride of a horse, one must ride behind.'

MRS THRALE: I suppose, Sir, they could ride in panniers, one on each side.

JOHNSON: Then, Madam, the horse would throw them both.

MRS THRALE: Well, I hope that in another world the sexes will be more equal.

JOHNSON: Nature has given women so much power that the law has very wisely given them little.

MRS THRALE: Then, Sir, you are not of opinion with some who imagine that certain men and certain women are made for each other?

JOHNSON: To be sure not, Madam. I believe marriages would in general be as happy, and often would be more so, if they were all made by the Lord Chancellor upon a due consideration of characters and circumstances, without the parties having any choice in the matter.

MRS THRALE: *(Addressing the audience.)* On meeting Dr Johnson for the first time, I was warned about his appearance, but it was something of a shock nevertheless. His height was around six foot, without shoes, his neck short, his bones large, and his shoulders broad. His hands were handsome despite the dirt, and such deformities perpetual picking of the fingers produces. His leg too was very handsome. Dr Johnson was mine, my conquest, and because of him all London beat a path to my door – I am Mrs Thrale, the brewer's wife. However scandalmongers chose to gossip, Dr Johnson was the crown of my life with Henry Thrale. For my sake Dr Johnson concerned himself with the business of the brewery. For my sake, he composed election addresses for Mr Thrale when he stood for a member of Southwark. For my sake, he played with the children and comforted them. I was known as Doctor Johnson's Mrs Thrale. And the Doctors feelings for me? I think he was a man of great religious feeling but his wife was now dead, however unlike Mr Thrale I believe he

considered fornication outside of marriage to be a mortal sin. He did write to me once saying…

JOHNSON: That I certainly do love you better than any human being I ever saw.

MRS THRALE: I did often sit with him far into the night drinking tea…

JOHNSON: I am a bad sleeper.

MRS THRALE: Dr Johnson became a member of our family, and we gave him an apartment in our house in Southwark and our villa in Streatham. Our dining hour in Streatham, was moved from three to eight in accordance with the upper circles of society, and the procession to our table of famous and witty people never ceased.

JOHNSON: It was a small wonder considering how famous the Thrale dinners had become. Twenty one dishes at each course, and desserts of fruits, ices and creams. The Thrales spared no expense in looking after me and even engaged the footman to change my wig which had become singed and black with reading so close to the candles. Dear Mr Thrale could not be kept from eating, his health got worse. His physicians constantly warned him against full meals. He ate himself to death. Ah! My poor dear friend, I shall never eat an omelette with thee again. I then had hoped that I might marry Mrs Thrale, I would throw off my bush wig, wear a clean shirt and shave every day, give up snuff, learn how to eat vermicelli and leave off red flannel night-caps.

(JOHNSON addresses MRS THRALE.)

Viva, viva, la Padrona!
Tutta bella e tutta buona,
La Padrona un Angiolella,
Tutta buona et tutta bella,
Tutta bella et tutta buona

MRS THRALE: Poor man. But he never prevailed on me for his carnal appetite.

DR **JOHNSON:** But I wrote, 'If a man should ever wish to swive, let him look on Thrale at thirty-five.' No. I would have preferred Mrs Thrale whip me at a bedpost rather than satisfy my longings. I do think of myself as one of the politest men alive.

MRS THRALE: Indeed, Sir, for the praise of good breeding. You will not go into dinner till all the company has arrived.

JOHNSON: Even if I was hungry.

MRS THRALE: Or the hour ever so late.

JOHNSON: I would not displace an infant if sitting in a chair that I wanted.

MRS THRALE: And you are always more attentive to others than anybody is to you.

JOHNSON: Dear, dear Mrs Thrale.

They kiss.

MRS THRALE: Now, Sir I have given you some marks on subjects, you have a maximum score of twenty.

JOHNSON: Religion?

MRS THRALE: Twenty.

JOHNSON: Morality?

MRS THRALE: Twenty.

JOHNSON: Scholarship?

MRS THRALE: Twenty again, Sir.

JOHNSON: Wit?

MRS THRALE: Fifteen.

JOHNSON: Manners?

MRS THRALE: Zero.

JOHNSON: Good humour?

MRS THRALE: Zero again, Sir.

JOHNSON: So...I am an ungracious wretch. 'Fit for the mountains and the barbarous caves, Where manners ne'er were preach'd.'

MRS THRALE: *(Addressing the audience.)* When my husband died society had wished me marry Dr Johnson. He was not well at the time in any case, but must I, a woman in the prime of life, saddle myself with yet more illness and invalids? I had enough, I can tell you. And I was in love with another.

JOHNSON: *(Lifting the newspaper.)* Ladies and Gentlemen, let me tell you I could not bear this. My Lady, hear this. You were warned my Mistress. Your behaviour was intolerable. Mrs Thrale's second marriage has taken such horrible possession of my mind, that I cannot revert to any other subject. I am sorry and feel the worst kind of sorrow, that which is blended with shame. I am myself convinced that the poor woman is mad to contemplate a union so low with her daughter's music master. Indeed I have long suspected that her mind was disordered. She was the best mother, the best wife, the best friend, the most amiable member of society. She gave the most prudent attention to her husband's business during his illness and death. What has become of her? I bring the verdict. Lunacy.

MRS THRALE: I found this unbearable, the newspapers then started on Piozzi, it was too much, and we left for Italy. I could not bear to be seen in London, for I was ill, and looked frightful. I developed erysipelas, a horrid eruption of the skin. Not attractive, let me tell you. Never have I suffered as I did that year. Dr Johnson's words rang in my ear...

JOHNSON: Madam, I have ever treated you with love. I have loved you with virtuous affection. I have honoured

you with sincere esteem. Let not all our endearments
be forgotten, but let me have in this great distress your
pity and your prayers. You see I yet turn to you with my
complaints as to a settled and unalienable friend. Do
not, do not drive me from you for I have not deserved
either neglect or hatred. If I interpret it right, you are
ignominiously married, but if it is yet undone, let us once
more walk together. If you have abandoned your children
and your religion, God forgive your wickedness, if you
have forfeited your fame, and your country, may your folly
do you no further mischief. The tears stand in my eyes.

MRS THRALE appears in a spot.

MRS THRALE: I never saw the Doctor again. Samuel Johnson
died while I was in Italy. The press were very unkind to me
at the time, but nevertheless they were only too anxious
to see if I would publish my memoirs of the Doctor. There
were many contenders to write his life, and Mr Boswell
was in the end the most successful. Personally I have to
admit that I never liked that man and you can certainly
learn in his writings what he thought of me. A little, artful,
impudent, malignant devil. And what remains of Johnson?
Johnson's enduring soul is like some fine statue, the boast
of Greece and Rome, dazzling with complete perfection.

MRS THRALE exits.

JOHNSON: EXIT;

1. The term set in the margin of plays to mark the time
at which a player goes off the stage.

2. Recess; departure; act of quitting the stage; act of
quitting the theatre of life.

JOHNSON exits.

BOSWELL: The last time I saw Johnson we had got down upon
the foot pavement, and he called out 'Fare you well', and
without looking back, sprang away with a kind of pathetic
briskness. I was much affected by the death of my dear

and respected friend, and for many weeks could not do anything but weep bitterly. But finally I resolved to write the life of Johnson as my memorial to him. It was a seven year task. I chose Dr Johnson, not for the rarity, but for the love of him, of his wit, his geniality, his hunger for humanity, his triumphant reconciliation of the mundane with the spiritual. Such was the force and charm of Dr Johnson that one sometimes seemed to see his personal qualities mysteriously reappearing in those who knew him. He learned me the art of thinking, the power of seizing the useful substance of all he knew, and exhibiting it in a clear and forcible manner, so that knowledge, which we often see to be no better than lumber in men of dull understanding, was, in him, true, evident and actual wisdom.